COMPLETE
THE DRAWING

Inspiring | Educating | Creating | Entertaining

Brimming with creative inspiration, how-to projects, and useful information to enrich your everyday life, quarto.com is a favorite destination for those pursuing their interests and passions.

First published in 2021 by Chartwell Books, an imprint of The Quarto Group,
142 West 36th Street, 4th Floor, New York, NY 10018, USA
T (212) 779-4972 F (212) 779-6058 www.Quarto.com

Chartwell titles are also available at discount for retail, wholesale, promotional, and bulk purchase. For details, contact the Special Sales Manager by email at specialsales@quarto.com or by mail at The Quarto Group, Attn: Special Sales Manager, 100 Cummings Center Suite 265D, Beverly, MA 01915 USA.

10 9 8 7 6 5 4 3

ISBN: 978-0-7858-3928-6

Publisher: Rage Kindelsperger
Creative Director: Laura Drew
Managing Editor: Cara Donaldson
Project Editor: Leeann Moreau
Illustrator: Tristram Drew
Cover Design: Beth Middleworth

Printed in China

COMPLETE
THE DRAWING

DRAWING PROMPTS TO GET YOU STARTED

chartwell
books

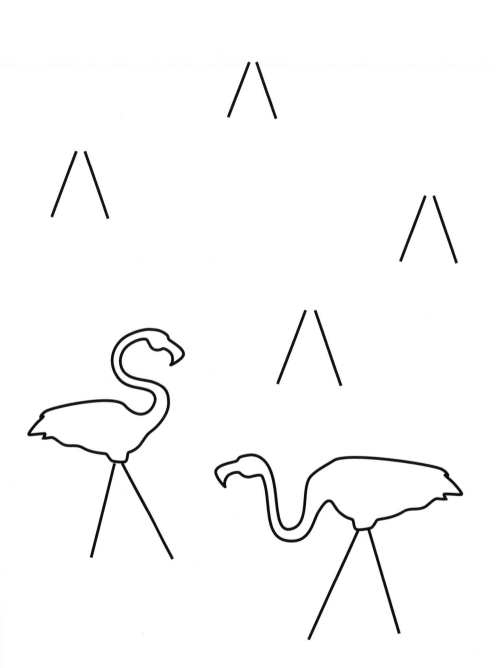

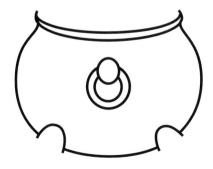

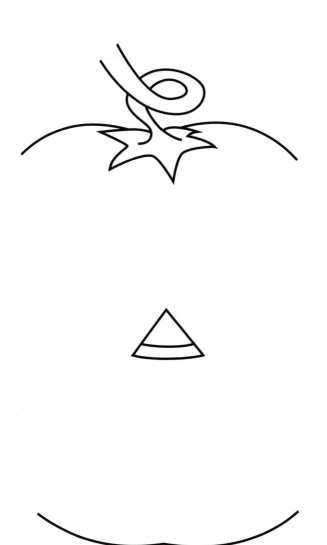

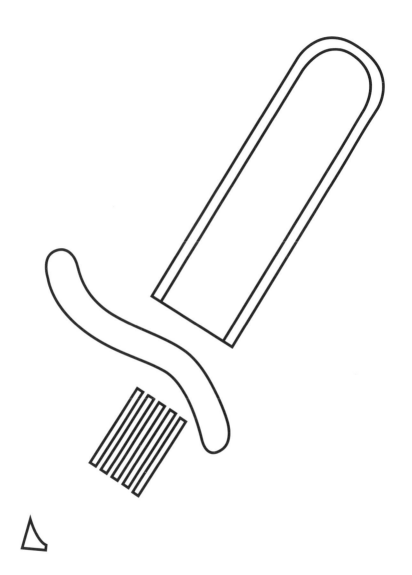

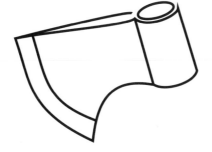

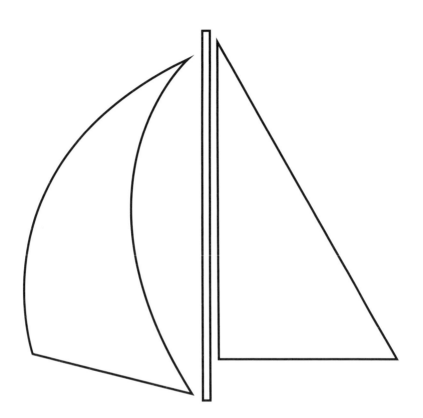

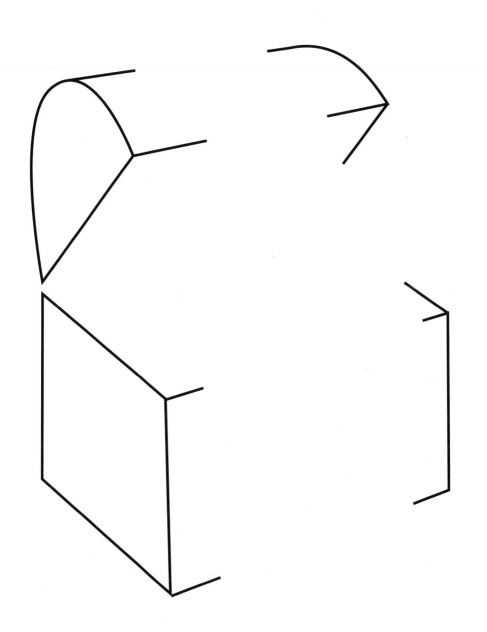

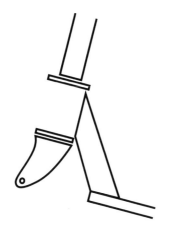

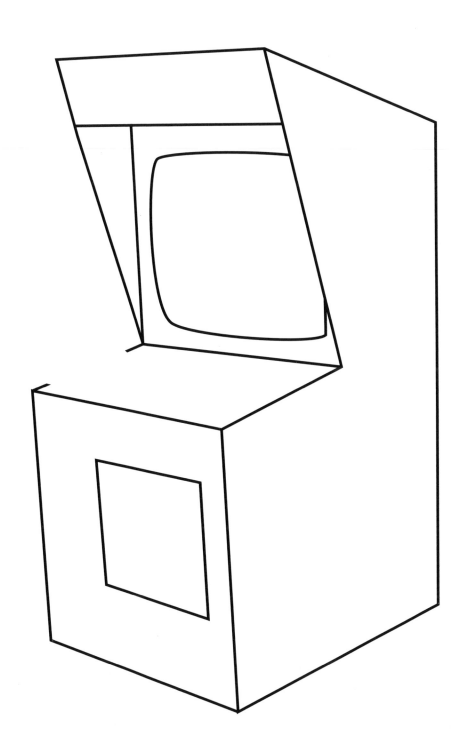

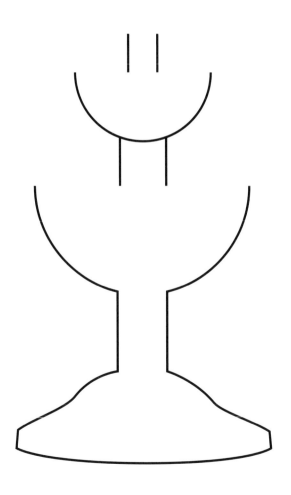

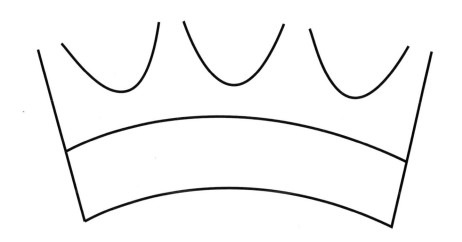

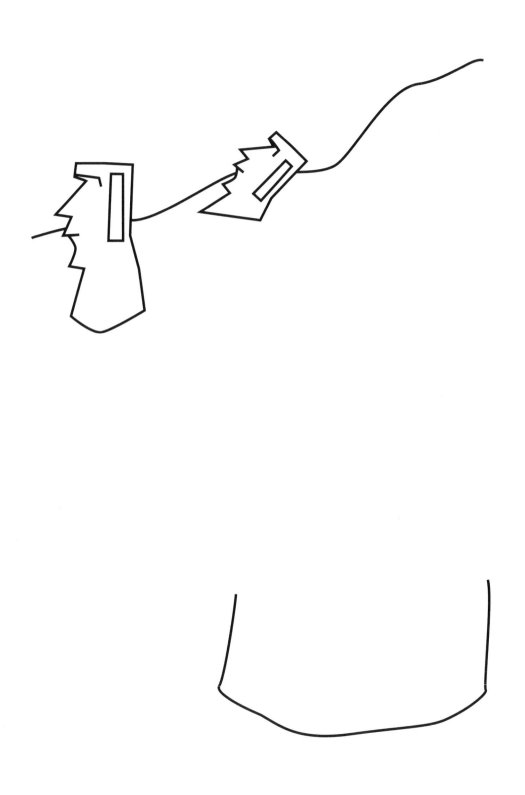

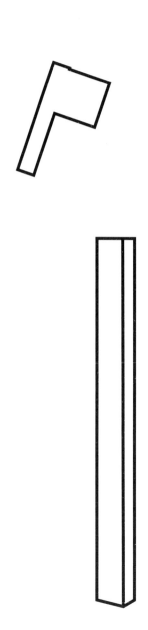